When the Nurse Becomes a Patient

LITERATURE AND MEDICINE

Michael Blackie, Editor

Carol Donley and Martin Kohn, Founding Editors

When the Nurse Becomes a Patient

A Story in Words and Images

Cortney Davis

THE KENT STATE UNIVERSITY PRESS

Kent, Ohio

For those who care for us when we are ill:
especially for my husband Jon,
and for the nurses, nursing assistants, and
physicians who cared for me

Foreword

The honest paintings in Cortney Davis's *When the Nurse Becomes a Patient* allow us to enter the experience of illness not from a bird's-eye view or across the table but from one brushstroke away. In twelve paintings and commentaries we see a woman's dependency unveiled, how the body becomes faceless, sexless, and totally exposed from the husking of our layered selves to be remade by the many hands, words, and deeds of caregivers. This is a civil war, and Davis is the nurse who strayed outside the fort. She was captured in the country of illness. If you are not afraid of the mouth's bear of terror, then take her hand, be brave enough to travel with her.

You will pass through heavy, sometimes smothering, darkness where the browns of Mother Earth called to her like sirens. Linger light as gauze above her sickbed for twenty-five nights as her cells serve time. Let Davis show you how she arm-wrestled the gods and escaped the forces who tried to snatch her body.

These primal paintings tell the story of falling off a cliff and having the guts to hang on. They let you see a woman's pantry where the best medicine is love. Cortney Davis has an ancient story to tell. The heart speaks. The hands paint. Her beautiful haunting paintings and reflections make us mindful of our bodies and the dust we will become.

Jeanne Bryner, RN, BA, CEN

Preface and Acknowledgments

As a registered nurse I've always known, intellectually, that the line between patient and caregiver is very thin. Especially when I worked in the Intensive Care Unit or on the Oncology ward, I understood that only an icy road or a few rebellious cells separated me from my patients. And yet, at the end of every shift, I was the one walking out of the hospital into the early evening air; I was the one who could leave.

Then, in the summer of 2013, I underwent routine one-day surgery that turned out to be anything but routine. Complications led to a second surgery, infection, and a prolonged illness; I was hospitalized twice for a total of twenty-six days. Like any patient, I was helpless in the face of sickness and dependent on the care and judgment of others. While I'd previously written poems and prose about my patients and my role as their nurse, I wondered if I could ever make creative sense of my own illness, and of the fragility and vulnerability of suffering.

During a long convalescence at home, I had neither the energy nor the words to release my feelings onto the page—the only way I could come to terms with my illness experience was to recreate that narrative through visual images. My heart seemed to connect immediately to the canvas through my arm, my hand, and my paintbrush. Bypassing the internal judge that often oversees my writing, I didn't worry about the accuracy of form, color, or technique. I simply painted my emotions.

Like so many who have been patients, I live with one hand reaching hopefully toward the future and the other hand unable to let go of the reality of mortality. I've learned the power of illness—to crush, to disorient, to humble, to humanize, to bond. Where once my comrades were the nurses, doctors and aides, my companions became the suffering patients, the men and women I'd pass in the hall, all of us managing our catheters and tubes, pushing our IV pumps and our swaying, colorful intravenous bags—the yellow of TPN, the red of chemotherapy—all of us nodding, silently acknowledging our kinship. I also learned again the power of creativity—to make sense of, to order, to keep, to release, and even to celebrate.

* * * * *

My gratitude to the editors of the following journals in which some of these images first appeared:
Pulse: Voices from the Heart of Medicine: "Dilaudid-Land"
Scrubs Magazine: "A Little Bit of Terror," "Transfusion"
Superstition Review: "On a Scale of One to Ten"

Transfusion

acrylic on canvas, 16" x 20"

During my first hospitalization, when my hemoglobin continued to hover in an unacceptable range, the doctors decided it was time for a transfusion. "Then," they said, "we'll see." It took some time for the transfusion to begin—the order entered into the computer, the lab person up to the room to draw my blood, the results sent to the blood bank, and eventually an evening nurse who appeared carrying the first of two units of dark red blood.

There seemed to be no end to the tests, the procedures, the complications, the medications, the side effects, and the pain. But as the blood began to snake down the IV tubing into my vein, I tried to sink into the process, to be a passive receptacle. *Whose blood was mingling with my own? Would this blood be a hindrance or a help?*

In this painting the white bed becomes a slab and, although in reality I was under several layers of blankets, my body here lies naked—I felt thin and pale, stripped emotionally and physically, and totally vulnerable. The yellow light shines in from the hallway; the blue form on the lower left represents the chair my husband sat in when he visited. But that evening I was alone, watching the slow progression of the transfusion, occasionally glancing out the window at the expanse of night sky over the city, which was living its own life ten floors below my hospital room.

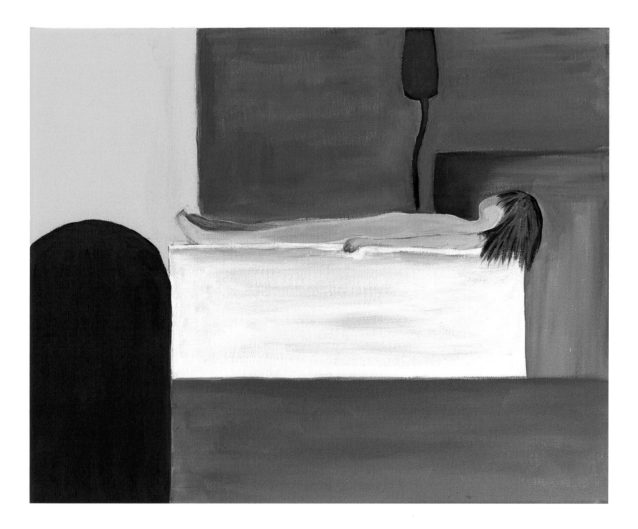

On a Scale of One to Ten

oil on canvas, 18" x 24"

I requested something for pain. The nurse asked, "On a scale of 1 to 10, if 10 is the worst pain you've ever experienced, how would you rate your pain level right now?" Every morning, the surgical residents asked me to rate my pain; the aides and my attending doctors also asked. In my room—in every patient's room—there was a poster of a row of round, cartoonish faces. Their expressions progressed from smiling on the left (no pain) to grimacing on the right (a 10) to help us assess where our pain fell in the continuum. Yet, as a nurse, I knew that every patient's pain is personal and therefore different from another's: one person's 10 might be another's 8. We can only compare our current pains to those our bodies already know. And our pain scales are fluid, ever changing.

Before this illness, my 10 was the writhing pain of passing a kidney stone; 9 was the intensely focused pain of a small bowel obstruction; 8 was the pain of natural childbirth, a cyclical, visceral pain that, at the end, at least offers you a wonderful gift. But there was one time during my hospitalization when my pain became a 12, instantly giving me a new standard of reference. My pain was intense, and so was my fear. Fear is pain's companion—and yet no caregiver asked me to rate my fear and, as a nurse, I'd rarely asked that of my patients. Medication might lessen our bodily pains, turning an 8 into a 5, but it doesn't necessarily render us less afraid.

This painting, with its bold red background and black outlines, represents not only the 10 of my worst pain but also the 10 of my fear. My face is not visible in the painting, only my mouth, distorted in a scream—the fundamental response to agony. During my hospital stays, I rarely wept and only once cried out in pain. Pain and fear can also be *internal* events. Those who suffer their pains quietly do not suffer less.

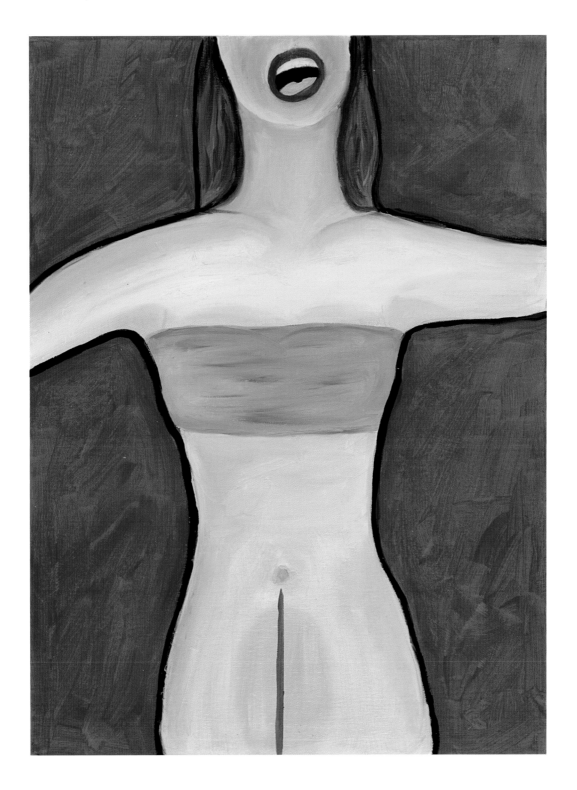

Dilaudid-Land

acrylic on canvas, 18" x 24"

The nurse entered my room carrying a hypodermic syringe. She bent over my bed, chose the correct port on my central line, wiped it off with alcohol, and slowly injected 0.5 milligrams of Dilaudid. Within seconds, the first rush of narcotic reached my brain. I felt a crushing sensation in my chest, as if I were being pushed down and down by some heavy hand. My whole body felt invaded, as if something alien rushed through my veins.

After the first distressing effects came a sensation of profound peace. Pain melted away. I became pleasantly drowsy, the same feeling I'd had as a child just falling asleep in a sunny summer room at nap time. In the first few moments in Dilaudid-Land, an unseen window opened, white curtains swayed gently in the breeze and, just beyond the window, the sound of waves and the scent of sea air beckoned me to sleep.

This peace was a temporary illusion; it was also the most disturbing peace I'd ever experienced. Part of my brain hammered me with an endless loop of bizarre half-asleep thoughts and half-awake dreams, disconnected and often frightening, while another part of my brain was self-aware and reflective—*what odd thoughts! I know they're not real. Where are they coming from?* My mind no longer belonged to me, and neither did my body. When the Dilaudid wore off, it was as if someone had dragged me back from that place where everything was both calm *and* horribly wrong into a reality in which everything was *only* horribly wrong.

In this painting, I'm floating on a deep and tranquil sea, my bed gently rocking and bearing me along. Here again my body is naked—I've been transported back to the innocence of childhood, that lovely nap. And yet, all is not well. Above and around me there is a storm gathering: purplish roiling clouds and a strange flash of light. A terrible sense of impending doom descends upon me. I am trapped in Dilaudid-Land.

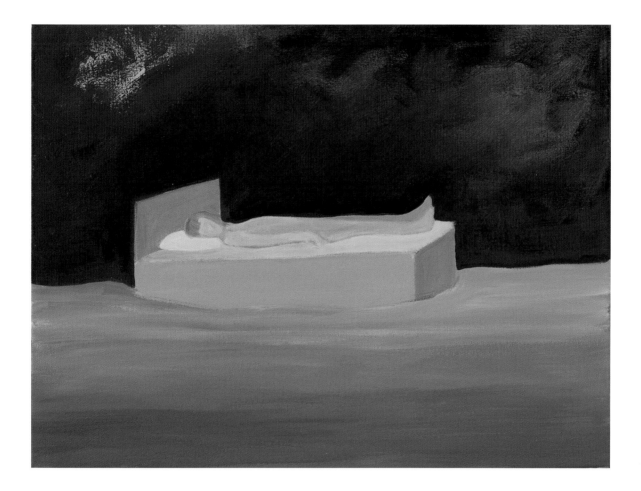

The Dark Night

acrylic and Prismacolor marker on canvas, 10" x 30"

All my life I've felt the presence of God around and within me. I never doubted this; I assumed this presence would always be there.

Maybe I took this for granted. Maybe I took my husband, family, and friends for granted. Maybe I needed my consciousness shaken up a bit. For whatever reason, one day during my hospitalization, God abandoned me. It was an abrupt and total departure. The very second that God left, another presence arrived, one that was palpably unkind and cold.

During the day, when my husband or others were with me, this new presence lingered in the corner. At night, it sat at the edge of my bed, slowly crawling its way into my mind and body. It overtook me; it left no space for prayer. I couldn't have called out to God if I'd wanted to. And, most terrifying, I didn't want to. I'd been plunged into a dark night that lasted for weeks and held no promise of dawn. Why had this presence driven God away? Had God permitted this to happen? Had I unknowingly invited this presence in? Or was it God Himself, this heavy weight?

This painting represents the time of "the dark night." The long narrow canvas seemed perfect; the painting is somber in tone, utilizing only black, white, and ultramarine blue with dashes of red. The tears on my face are tears of confusion and fear. The black shapes that began simply as geometric patterns morphed (at first unconsciously) into the suggestion of a cross—I felt both abandoned and crushed: what was God asking of me?

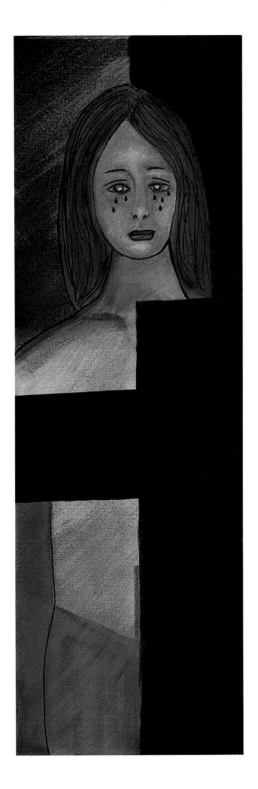

The Dark Night 2

acrylic with collage on canvas, 20" x 24"

The time of the "dark night" was one of the most frightening aspects of
my hospitalizations, more present during my first weeks as a patient
but still lingering and only slowly vanishing over time. This painting
reveals how invasive and pervasive this dark, cold, and unkind presence
felt to me. It tells of a particularly ugly time.

I am the spectral woman in black, abandoned by God, standing
before her hospital bed, that white slab. My face, drawn in pencil and
affixed to the canvas, is smudged and frowning—I felt as out of focus
and fragile as this piece of paper. Behind me, almost a part of me,
lurks the presence. It hovered over me; it felt like a heavy cloak, an
amorphous shape that wanted to inhabit me entirely. There seemed to
be nothing else needed on the canvas—only a background of black with
a hint of red, a bit of orange.

This dark night did eventually end. It ended because of the love of
my husband, my children, my grandchildren, my friends, and all those
who prayed with and for me.

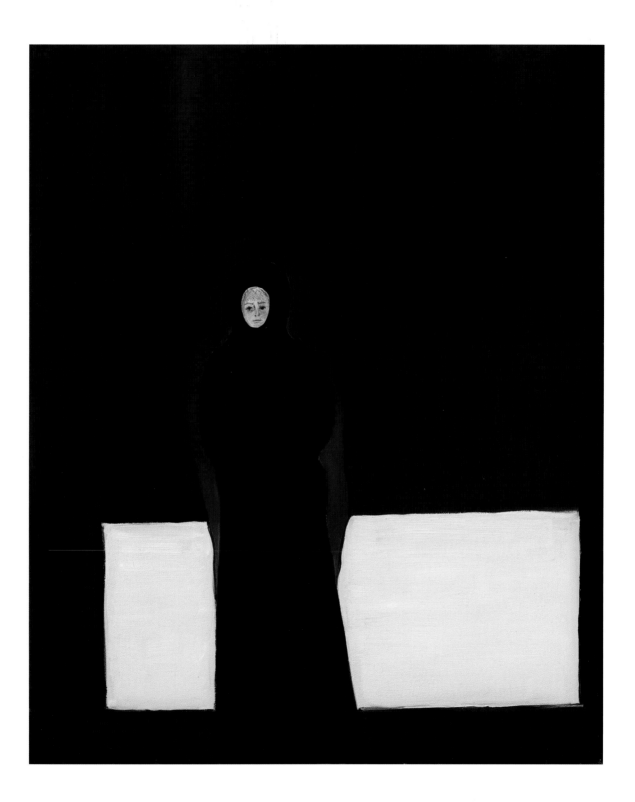

Last Rites

oil on canvas, 18" x 24"

I received The Sacrament of the Sick twice during my hospitalization. Both times, after, I felt prepared to die—or if I might live, fortified to persevere. But how does one portray in image the transcendent feeling of preparing the soul for death?

My face and the face of the priest are featureless: my face because I felt so emptied of life, and the priest's because when a priest functions in *persona Christi,* in the person of Christ, his human nature is hidden. The priest's personality becomes secondary; his physical appearance is unimportant.

The bright colors and the radiating "scratches" on the surface of the painting were not planned as much as discovered along the way. The experience of receiving what might have been my life's last sacraments was electrifying, profound, and otherworldly—beyond any words I might write here—and only thick, vibrant colors and radiating shock waves seemed artistically and metaphorically right.

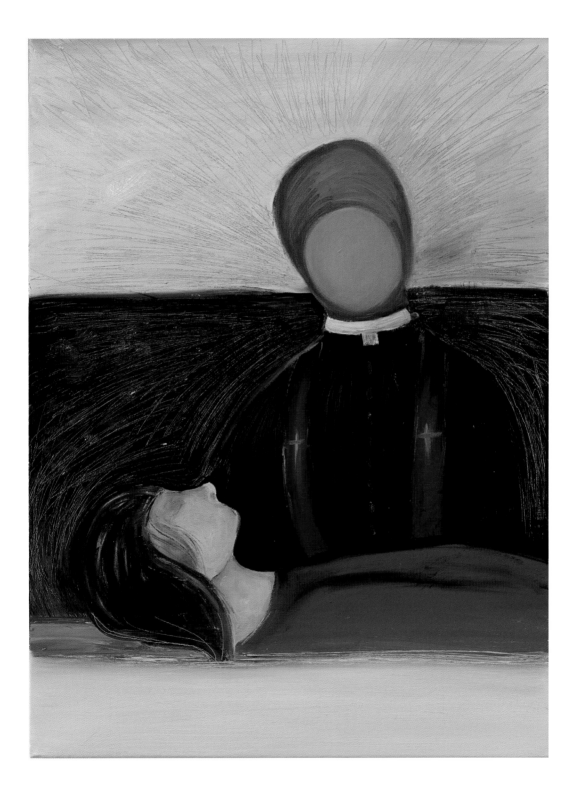

My Husband Cares for Me Tenderly

oil on canvas, 16" x 20"

During the weeks of my first hospitalization, my husband sat with me from morning until late night—waiting beside, helping, soothing, comforting. I would not have survived that terrible time without him. During my second hospitalization and through my recovery at home, he continued to be a constant support and an attentive caregiver, urging me to walk, to eat, to rest, to tolerate the treatments and side effects, to recover.

I wanted to express what my husband's concern and loving care meant to me—his vigil was heightened, essential, and almost superhuman. The blues and oranges of this painting seem otherworldly. There was something unreal about my whole illness. At the same time, it was in many ways more real than my day-to-day life had been. Painting this, I felt again my own helplessness as well as the reassurance I found in my husband's embrace. I also felt his anguish, his own separate, individual, and equally life-altering suffering.

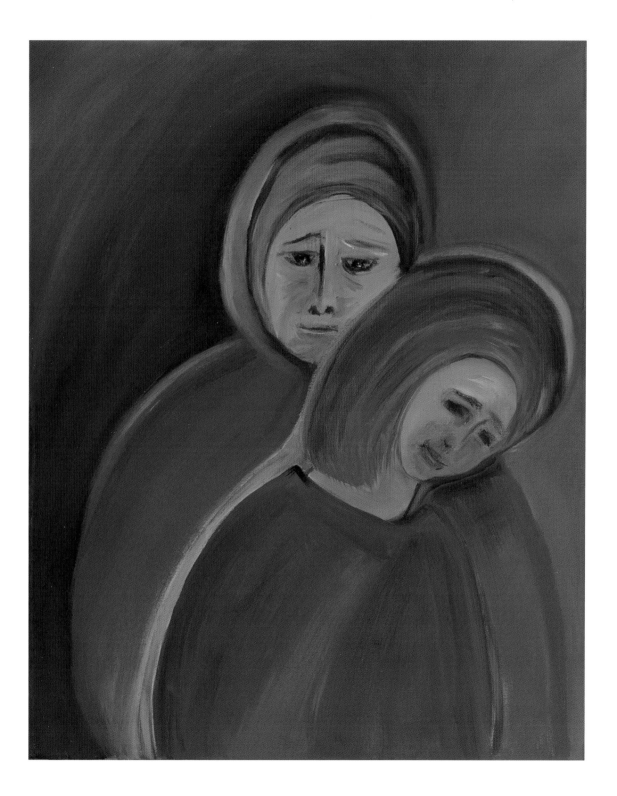

Twenty-Five Nights

acrylic with collage on canvas, 18" x 24"

Altogether I was hospitalized for twenty-six days and twenty-
five nights. As every patient knows, the night hours are the most
difficult. Pain is intensified, as is loneliness. The daytime noises
become nighttime noises: confused patients cry out, often over and
over; nurses talk and laugh, for some reason with greater abandon
than during the day; workers on break gather outside the elevators
or in the hallways, gossiping and joking in a variety of languages;
sleepless family members gather around the TV in the waiting
room, the volume turned up until the voices of talk show guests
pass through the walls like incessantly chattering ghosts.

 I dreaded the hours between 8 P.M. and 5 A.M. Most nights I
simply stared at the ceiling or at the clock on the wall, the hands
luminous in the dark. Minutes dragged. Hours pulled themselves
slowly through their allotted time. Pain medication rarely blessed
me with sleep, only with odd and often frightening thoughts. At
irregular intervals my room lights blazed on whenever aides
appeared to check my vital signs or nurses came to assess, with their
cold stethoscopes, my belly, lungs, and heart. IVs were changed;
medications were hung; drains were emptied; alarms cried out their
beep beep beep. Just as suddenly, the lights would be extinguished,
shrouding my room once again in shadow.

 The twenty-five "stars" on the canvas represent my twenty-five
hospital nights. The figure of the woman, floating and ethereal, was
painted in watercolor and then affixed to the acrylic background.
She is based on the archetype of the doomed but lovely young
woman, dead before her time—*La Jeune Martyre,* Ophelia, the
Lady of Shalott—in the paintings of Paul Delaroche, John William
Waterhouse, Gustave Doré, and others. Why did I choose to
represent myself as this otherworldly woman? Because during my
twenty-five nights, I always left the window curtain open. I could see
out to the night sky, stars glittering against the deep nocturnal blue.
Sometimes I seemed to be floating among them. Sometimes I felt as if
I were dying, or had died, and was simply waiting to be carried away.

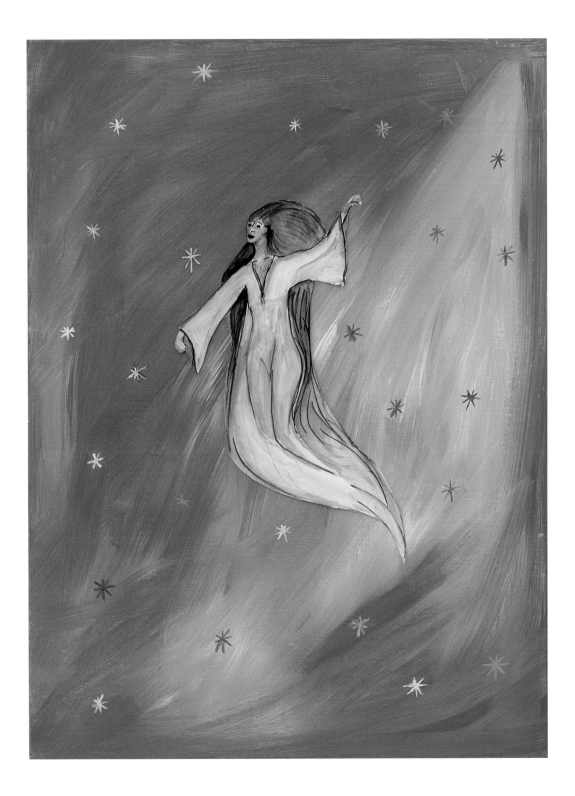

A Little Bit of Terror

acrylic with collage on canvas, 16" x 20"

When I was first discharged from the hospital, I felt fragmented, uncertain, and not prepared to resume any kind of "normal" life. Within days my clinical symptoms worsened and back to the hospital I went, via ambulance, sirens wailing. More procedures were done; another round of tests revealed that I had developed a blood infection and a pleural effusion—fluid trapped between the lung and its covering, the pleura—which were the results of surgical complications and the various medical treatments I'd received.

This painting depicts the raw fear I experienced when I was home in between my two hospitalizations. Still anemic in spite of transfusions, I felt my body changed and, metaphorically, broken apart. Normally slender, I now looked skeletal—there was no part of me that seemed familiar. Whose skin was this, whose hands? Whose legs supported me?

I gained new insight into how my patients might have felt when they were released from hospital to home: as terrifying as being in the hospital can be, being home, especially alone, is equally frightening. Worries loom large. Nothing is easy. The simplest chore, the most routine task, seems impossible. Everything becomes bright and out of focus, like that small piece of paper collaged into the painting, appearing to be a part of my hair but also a part of my jangled consciousness, a little bit of terror. I'm asking, "Where are the nurses with their tender hands? How will I survive, and what awaits me now?"

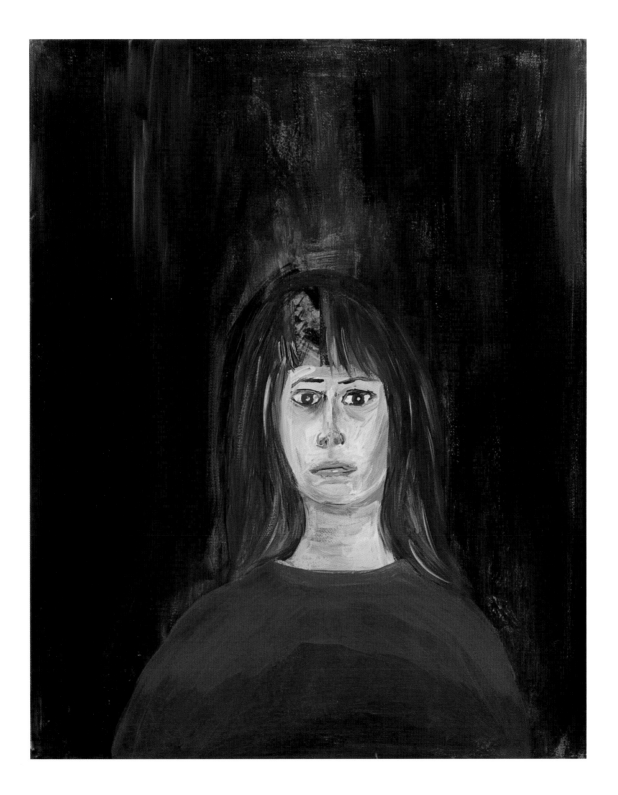

CT Scan

acrylic on canvas, 16" x 20"

During my illness, I had four CT scans: the first was a scan of my abdomen after the initial surgery; the next, a repeat scan after the second surgery; the third was a chest and abdominal scan at the beginning of my second hospitalization; the fourth, done during my recovery, reevaluated the status of my chest, abdomen, and pelvis.

The CT scan itself—the few minutes one is "inside" the scanner—is not physically painful, although the hot flush that follows the intravenously administered contrast is a bit disconcerting. Nevertheless, I dreaded every CT scan that was ordered. I drank the oral contrast with difficulty, already nauseated from the surgery and medications, but urged on by my surgeon, my husband, and the radiologist who said, "You wouldn't want to have the scan and not get all the information you could from it . . . would you?" Because I'm allergic to the IV contrast, I received premedication with steroids and Benadryl and arrived in radiology feeling both internally "hyper" from the steroids and "knocked out" by the Benadryl.

This painting represents my dread of *one more test* and all it entailed and my fear about what the scan results might mean—more surgery, more medications, another lung tap, more days and nights in the hospital. In the painting, my body is divided, my face half dark blue, half light. I felt suspended between illness and the hope of health, between life and the threat of death. My body on the stretcher appears shrouded, as if wrapped in a burial cloth, although in reality I was cold and therefore swaddled in blankets. I was "attached" to IVs and monitors; there was various medical equipment nearby in the room; and the scanner loomed—open, airy, and with a little smiley face that indicated when to hold your breath. Just before the scan was started, the technicians left the room. For me, that moment was one of sudden and piercing aloneness. In the painting, therefore, all equipment and personnel are absent: it is just my body, pure flesh, being moved into the scanner, silver metallic on the outside and, inside, the black abyss of the unknown.

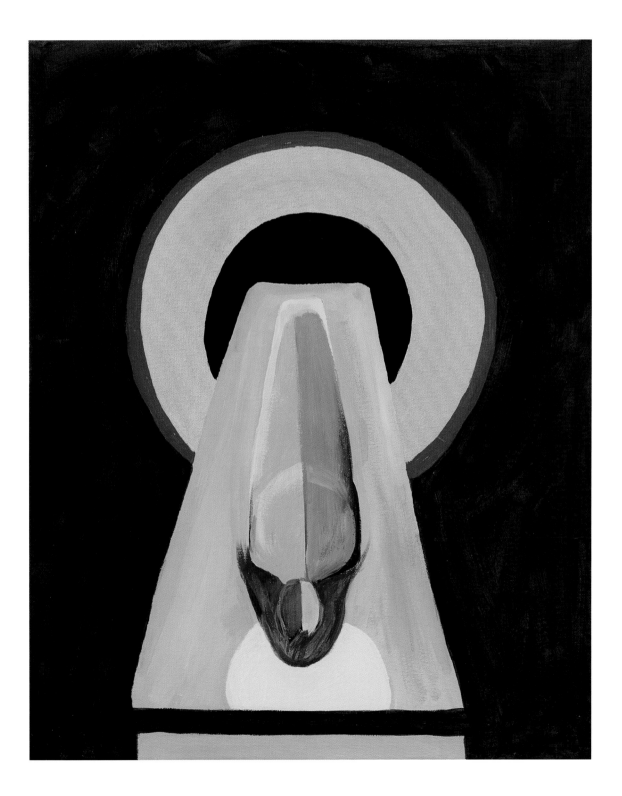

I Offer My Suffering

acrylic with collage on canvas, 18" x 24"

There is much that I can't recall about my hospitalizations. I do know that my mind seemed separate from my body. While my body was exhausted and seemingly not my own, my mind was often hyperactive, as if electrically charged. I spent hours contemplating the nature of suffering—not only my own, but the larger, cosmic meaning. Why do we suffer? Why am I suffering now?

As my illness persisted and then waned, I began to understand that my suffering was, in ways I cannot fully explain, a gift. I saw myself as I really *am,* perhaps for the first time—not the illusion of self I create every day but the reality and consequences of my actions, my beliefs, my strengths, and how I've used or misused them. I saw, deeply, into my soul.

At the same time, suffering took me out of myself. I realized, viscerally, how little I had understood or responded to my patients' sufferings, the sufferings of my parents, my children, my grandchildren, my husband, and my friends. The sufferings of the world became mine as well. My individual, highly personal suffering became something of value. I offered my suffering for the benefit of others, especially my loved ones. I knew that my suffering joined me to all those who were, who had been, or who would be suffering.

In this painting, I'm young again—because there is something purifying about suffering—dressed in what might be a patient's gown or a nurse's white uniform. On the left side of the canvas, the waning moon shines against the dark night sky of illness; on the right, the yellow circle becomes the healing sun. And yet, even as I willingly offer my suffering, my expression is wary. I'm hesitant. I'm human. I wonder, will I ever have to go through this again? If so, will I have the fortitude to endure?

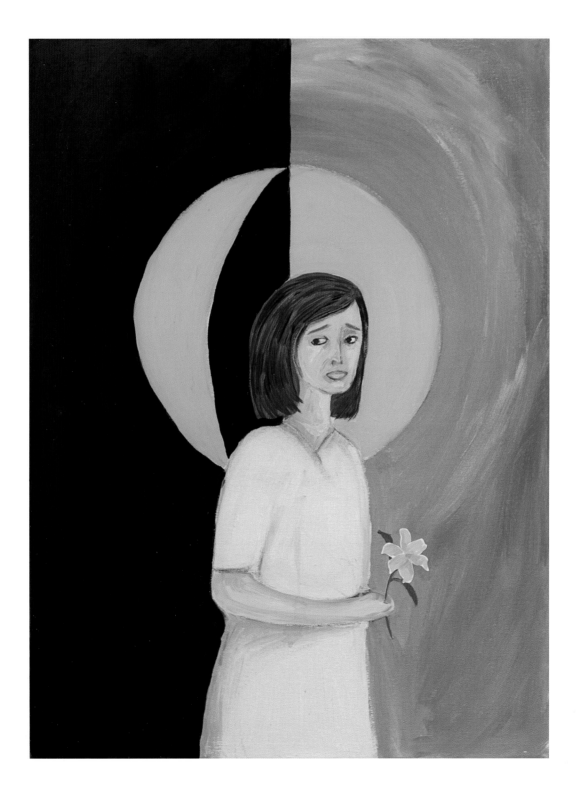

Angel Band

acrylic on canvas, 20" x 24"

I first heard the old American gospel song "Angel Band" many years ago. Over time I heard the song performed by different singers with different styles. No matter the version, the song always moved me with its blend of pathos and acceptance: the narrator is awaiting death, calling to the angels who will take her home. My favorite renditions are those of Emmylou Harris and Marideth Sisco. Both sing "Angel Band" with a distinctive longing—"Oh come, angel band. Come and around me stand."

During my hospitalizations, there were hours and days when I wasn't sure I would live or if I even wanted to live. I would have welcomed the angel band whose task it would be to carry me away. As I recovered, I realized that my angel band had in fact been gathered around me all the while. They were the nurses and aides who cared for me; they were my husband and my family; they were the friends who came to stay with me in the hospital when my husband couldn't be there; they were all those who kept me in their thoughts, who sent flowers and cards, who prayed for my recovery, who brought food to my husband and me once I was home.

This painting is in thanksgiving for those angels—here they have come again (a few representing many) to "around me stand." The use of pure colors, the repeating round shapes and the lack of facial details are in homage to one of my favorite painters, Milton Avery (1885–1965). Looking at his paintings brings me a sense of calm, of quiet joy. Contemplating my angel band now, in convalescence, I feel those same emotions—these angels saved my life. In this painting, I want to express what I couldn't always say during my illness: *I owe you profound thanks; I look upon you with love and immense gratitude; I am forever in your debt.*

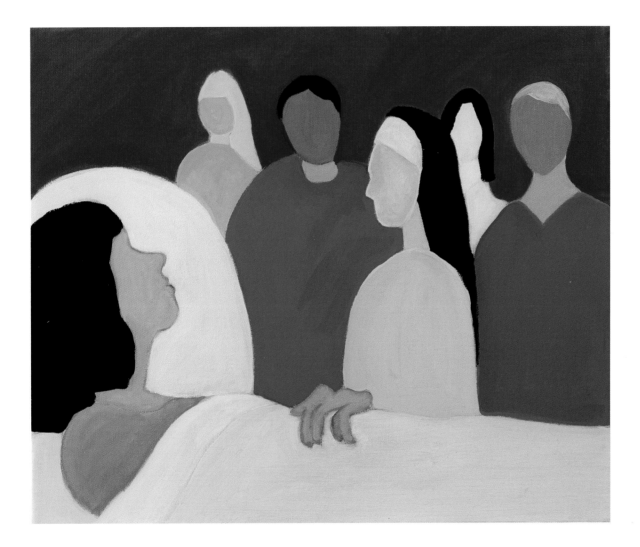

Afterword

Last year at this time I'd been home from the hospital for two weeks—still on medication, still in need of help with the simplest tasks, still waiting for tests to come back "normal." It would be another six months before I felt if not cured, definitely better. Now, as I write this, I am 98% recovered. I gladly accept my 2% of leftover physical symptoms because they prove I'm alive; they remind me how vulnerable we are, and yet how strong.

The other day a friend asked what I'd learned from all this. I hope that some of what I learned, at least on an emotional level, might be evident in these paintings and commentaries. I also realize that the lessons I learned might have been meant specifically for me. Just as we experience pain in individual ways, perhaps life lessons come to us for our particular needs, maybe not understood at the moment but seen more clearly in retrospect.

I am, in a profound way, aware of how essential nursing care is for all patients. Medicine has changed. It is less personal, less interactive, and more technical. Nursing has changed too, but the presence of nurses and aides at the bedside is still critical, perhaps now more than ever. These caregivers tend us, and their touch is comforting; they encourage us and do not judge us; they are our wise guides and advocates. Without good nursing care, patients cannot survive.

There were weeks when I felt abandoned by God. I know now that I was never abandoned, although I was certainly tested. I'm sure that other patients have or will experience their own "dark night." If we're aware of this possibility, we might offer help.

I learned how completely, in the midst of illness, we can lose ourselves. Our routines, our bodies, our minds escape us. We may feel as if we are lost in a strange land without luggage or money, without friends or a way home. Even for the most ill, human presence is healing. Speech is unnecessary; just sitting silently by can be of great service. Another gift is listening, especially during a patient's recovery. Talking about what I endured pinned the experience down; it made it real and therefore less frightening.

Finally, as I go about my day, I am thankful for every breath, every meal, every moment. And yet, I also carry with me the cries of pain and fear I heard nightly in the hospital. I'm aware that there are always others who are suffering. In the midst of my greatest happiness, I think of them.

Cortney Davis
August 2014